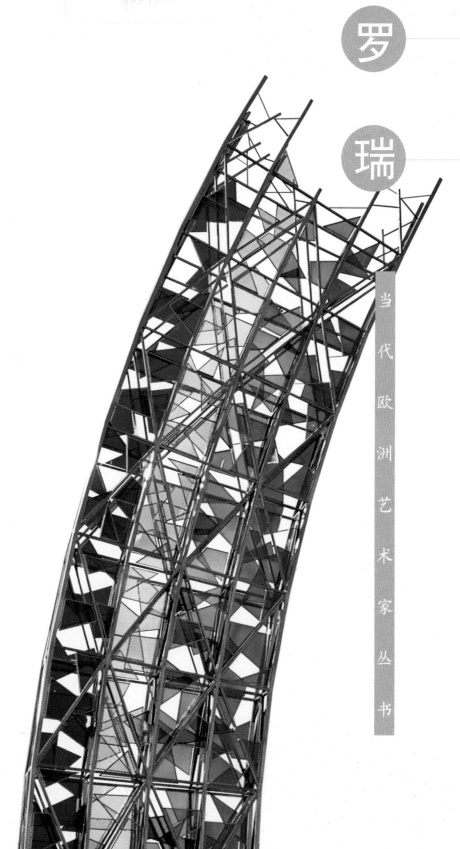

罗

瑞

当代欧洲艺术家丛书

总　序

1999 年 11 月，"中国欧洲艺术中心"在我的同事，来自荷兰的依尼卡·顾蒙逊女士（Ineke Gudmundsson）和厦门大学艺术学院的共同筹建下成立。艺术中心的具体工作由依尼卡和我共同运作，这对我来说是一个新的尝试和愉快的经历。

在过去近四年的时间里，"中国欧洲艺术中心"成功地为当代欧洲艺术家分别举办展览达 30 余次。展览对象是那些具有一定代表性的当代欧洲实验性艺术，时间跨度是自 20 世纪 70 年代至现在。

"中国欧洲艺术中心"的活动宗旨是：在中国和欧洲之间架起一座艺术与文化交流的桥梁，为中国和欧洲艺术家们营造一个更加直接的交流平台。

对"中国欧洲艺术中心"来说，过去的四年是一个颇有启示性的经历和富有收获的阶段。它使我站在新的理解层面上，从一个全新的位置上来看待当代欧洲艺术。与当代艺术的生成紧密相连的是生活体验，和用新的形式手段去表现新的想法。我们的基本原则是，展示真正的具有原创性的新艺术，而不仅仅是那些在主流想法上呈现的各种变化。视觉艺术是当代文化的一个重要组成部分。艺术实践不再仅仅是为受过训练的观众所理解的孤立想法与情感表达。相反，在今天，就像经济和科技的迅速和巨大的发展一样，当代艺术的确进入了一个对文化本身进行不断的质疑，并由此导致突破与发现的过程之中。

在国内的艺术圈内，经常有这么一种说法，在过去 20 多年的时间里，中国把西方 100 多年的现、当代艺术几乎过滤了一遍。对外来艺术以及它的所有规则吸收的速度如此之快，这自然是一个特殊的现象。从这个意义上看"中国欧洲艺术中心"的工作目的是很清楚的，即通过一个相对长久的过程，向国内观众介绍当代欧洲艺术。

《当代欧洲艺术家丛书》是"中国欧洲艺术中心"工作的一个延续，丛书中介绍的八位艺术家都曾经在"中国欧洲艺术中心"举办过个人展览。我们希望这套丛书只是我们出版规划的一个开始。

最后，我谨向对该项目给予支持的如下机构和个人深表感谢：

荷兰蒙德里安基金会（阿姆斯特丹）
挪威王国驻中国大使馆，北京
挪威外交部，奥斯陆
冰岛共和国驻中国大使馆，北京
冰岛教育部（雷克雅未克）
美国芝加哥艺术学院 Lisa Norton 女士

厦门大学艺术学院中国欧洲艺术中心

秦　俭

2003 年 5 月

PREFACE

In November of 1999, the Chinese European Art Center was jointly founded by my colleague, Ineke Gudmundsson of the Netherlands and the Art College of Xiamen University. It has been my pleasure to collaborate with Ineke in directing and administering the CEAC on behalf of the Xiamen University Art College.

Over the past four years, the Chinese European Art Center has presented over thirty exhibitions of contemporary European artists to a predominantly Chinese audience. Works exhibited over the years represent the trends in European contemporary and experimental art from the 1970's to the present.

The mission of the Chinese European Art Center is to build a bridge for art and cultural exchange between China and Europe, as well as a platform for communication between Chinese and European artists.

This has been an inspirational period of experiences and achievements for the Chinese European Art Center. It has brought me to a new level of understanding of contemporary European art as seen from an entirely new vantage point. Contemporary art relates closely to life experiences, and expresses new ideas by means of new forms. Our guiding principle has been to exhibit truly innovative new art rather than mere variations on trendy ideas. Visual art is an important part of contemporary living culture. The practice of art is no longer an isolated expression of thoughts and feelings understood only by a trained audience. On the contrary, today, like economics, sciences and technology, the rapid and great development of contemporary art is indeed undergoing a process of questioning resulting in breakthroughs and discoveries about the nature of culture itself.

In Chinese art circles, there is a saying that in the past twenty years, China has percolated all the modern and post-modern art forms created by Western artists over the past century. The speed of assimilation in the arts, as with all the disciplines, is due China's unique situation in the last twenty years. The aim of the Chinese European Art Center is a successful model of this same process—to introduce contemporary European art to China on a long-term basis.

The publication of A Series of Contemporary European Artists is an extension of the work at the Chinese European Art Center, for all the eight artists have previously exhibited their works at the CEAC. Our hope is that this volume is just the beginning of a series of publishing projects.

My deep thanks to the following institutions and individuals for making this project possible:

The artists
Mondrian Foundation, Amsterdam, The Netherlands
The Royal Norwegian Embassy, Beijing
The Ministry of Foreign Affairs, Oslo, Norway
The Embassy of the Icelandic Republic in Beijing
The Ministry of Education, Reykjavik, Iceland
Lisa Norton, The School of the Art Institute of Chicago, USA

Qin Jian
The Chinese European Art Center of Xiamen University Art College

May of 2003

罗 瑞 的 艺 术

冰岛视觉艺术家罗瑞的作品处处显示出独特的美与平衡。

作品或许是短暂的——就像一道彩虹的显现那样，具有暂时和流动的特征，它们也许组成了一个过程（总是在人的指导之下），或者它们也许具有事物的永恒性特征；但是，它们同样可能从一个阶段到另一个阶段，从一个地方到另一个地方获得了发展，经过几年的时间达到一种完整。接着是过程的显示和延续的阶段，它们给我们留下深刻的印象。

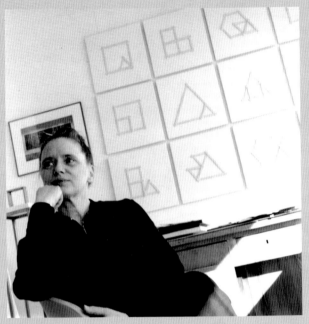

作品均与时间和人类在时间中为建构、指令和理解的景况所做的努力有关。归类、测量和系统是人类存在的证明。它还建立起物质的结构并且竭力加以维持。一旦力量不复存在，人类便会一点一点地消亡。不是时间，而是时间中的无法维持的过程摧毁了他们。通过时间自然能再一次获得他们……曾有一时，他们是可以看得见的时间流逝的符号。

罗瑞的作品是在秩序、过程、看得见的时间推移、永久的自然力量的领域之中产生。

历经数年，她集中精力在这个领域的很大的范围里使用各种手段和材料进行创作。

在我的心目中，一件非常重要的罗瑞的作品是我只在图片文献上看到的雕塑《彩虹之一》，作于1983年，用的材料是手绘的纺织品和竹子，17米高，罗瑞在靠近海边的冰岛外景处竖立了一道彩虹，这是一个以彩虹的色彩秩序画在布上的一个细长的结构。然后她在彩虹的底端部点上火，顷刻间，彩虹在火光中消失。

不管罗瑞为点燃所选择的材料是多么的简单——有时近于平淡无奇，但是它们总是被赋予一种抒情的特质。甚至是1984年她在哥本哈根的广场上放置的沉重的水泥废墟，也比那种玩命似的描绘更富有诗意，尽管它与实际水泥的联系非常真实。

罗瑞的作品是观念性的，作品中所表达的东西多与精确的观念和依据一种理论或者一种理解相联系，但它们都具有一个明确和感觉的方向，在材料的选择上这两者均得到了体现。在这样的手段中，它们达到果断和贴切。通过这样的手段，她把我们带入作品的内涵中去。

1992年罗瑞创作的《测量作品》便体现了这样的事实：我们在作品中所遇到的是一个暗示性的表面，与所用的工具——木匠用的折叠尺相比，它带有触觉的魅力和"温暖"，我们用此去把握和操纵——去测量，从而带来秩序。在每一件作品中，效用只与一个测量有关，在长度上，它有一个具体的尺子的数字。但是靠着对工具的操纵，尺子可以呈现出各种形象。同样，一件作品可以由观察者对待的角度和情景去界定，以各种不同的方式去阐释——而且作品本身仍然保持不变。这里，人类以其自身的多种可能性和差异性，同时以其自身的局限性呈现出来。

在1995至1996年期间创作的《测量作品》，（现在在布斯克画廊展出），其性质与罗瑞的早期作品不同，它们依靠简单的几何形和观念。木匠用的尺子在很大程度上保持了自身物体的特征，尺子与地板和墙壁直接构成联系。尺子成为作品的惟一材料。

当每一件作品组成了尺子的一个详细数字，或者与木匠的尺子的一个长度数字相结合时，每一件作品都暗示着一个可以辨认的方形和立方形的尺子的数字。作品凸现了在观念和人的具体的操纵之间的联系。罗瑞的所有作品都在观念和材料之间获得了一种平衡，对双方的理解是相等的，它们在一个明显的方式中得以结合。罗瑞经常致力于发现双方的靠近并使之成为相互对照。

丹麦艺术批评家 Grethe Grathwol
1997

RÚRÍ

Everywhere in works by Icelandic visual artist Rúri a unique beauty and balance is present; they are clarified.

The works may be ephemeral—as temporary and fleeting of character as a rainbow, they may consist of a process (which is always documented), or they may be of a permanent character, objects; but they may also develop stage by stage, place by place, for years to reach a wholeness. Then it is the states along the way which reveals and the continuity of the process which strikes us.

The work all deal with time and the efforts of the human being to structure, order and comprehend the conditions in which it is placed. The human being sorts, measures, systematize. It also builds up physical structures and strives to maintain them. Once the strength and will no longer exist they perish, little by little. It is not time which destroys them, but the process undergone by unsustained objects in the course of time, through which nature is enabled to re-acquire them, wrench them back. For a while they are the visible signs of the passing of time.

It is in the field of order, of process, of the discernible passage of time, of the permanence of the forces of nature, that Rúri works. Through the course of the years she has focused on and worked in a wide variety of the areas of this field, using various means and materials.

To my mind, one of the very central works of Rúri's production, and which I have only seen in photo documentation, is Rainbow I, 1983, a sculpture, of hand-painted fabric and bamboo, 17 metres high—and film. Rúri erected a rainbow in the Icelandic landscape near the sea, slender with cloth colored in rainbow colors. She then set fire to it at the bottom and it rapidly disappeared in the flare of the flames.

No matter how elementary—at times almost prosaic—are the materials Rúri chooses for her creating, they are always endowed with a lyrical dimension. Even the heavy concrete ruin she placed on the square Kultorvet in Copenhagen in 1984 was, despite its authentic reference to actual concrete ruins, more poem than heavyweight narrative. Times intersect in lyricism.

Her works are conceptual in the sense that they are linked to precise ideas and based on theory or a perception, but they all have a tangible and sensual aspect, both in the choice of materials as in presentation. By such means they acquire an immediacy and relevance. By such means does she draw us further into the works.

Such is the case with "The metre works" form 1992, where we encounter the flat surfaces of lead, with its tactile attraction and "warmth" in confrontation with the tool, the carpenter's rule, which we are used to grasping and manipulating—to measure, to bring order. Within each of these works the operation involves only one measure, a specific number of metres in length, but depending upon the manipulation of the tool it observer, unaltered. Here the human being is present with its manifold possibilities and differences, at the same time its limitations.

"The metre works" 1995-1996, which are now own on exhibition at Galerie Bossky, are of a character different from that of the earlier works, as they are based on simple geometric forms and concepts. Here the carpenter's rule preserves its object character to a greater extent, as it relates directly to floor and wall. It is the only material in the work.

Each work is comprised of a specific number of metres—or the combined length of a number of carpenter's rules—each at the same time suggesting a discernible number of square or cubic maters. The works demonstrate the connection between the idea and the human's concrete handling of it. Throughout Rúri works there is a balance between idea and material, both aspects are equally perceptible and joined together in an obvious manner—even mirror each other.

<div style="text-align: right">

Grethe Grathwol
1997

</div>

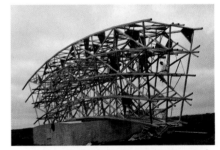

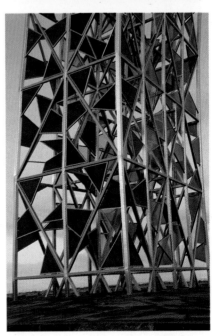

个人简历 RÙRÍ

1951 出生于雷克雅未克,在冰岛和荷兰接受教育,生活和工作在冰岛、荷兰、丹麦、芬兰和瑞典

部分个人展览
1977 至点,冰岛
1978 阿姆斯特丹,荷兰
1979 美术馆,阿姆斯特丹
1979 38 号美术馆和 2 号美术馆,哥本哈根,丹麦
1982 彩虹一号,冰岛
1983 大地的诗,冰岛
1987 残缺的时间,瑞典
1991 相对性,艺术博物馆,冰岛
1991 价值,美术馆,芬兰
1996 相对性,美术馆,丹麦
1997 乐园？—什么时候？,艺术博物馆,冰岛
1998 四种力量,冰岛
1999 消失的时间,冰岛

部分群体展览
1974 雷克雅未克雕塑家展,雷克雅未克艺术节,冰岛
1978 工作室,马德里,西班牙
1979 美术馆,佛罗伦萨,意大利
1979 北方女性艺术家,丹麦
1980 雷克雅未克雕塑家展,雷克雅未克艺术节
1980 环境实验之二,雷克雅未克
1981 表演,艺术中心,挪威
1982 巴黎双年展,巴黎
1983 双年展,西班牙
1983 水泥,艺术节,芬兰
1986 机场雕塑,雷克雅未克艺术博物馆
1988 国际第一号邮政艺术展,西班牙
1989 交通,斯德哥尔摩国家博物馆
1984 艺术—自然,意大利
1985 思想,北欧艺术中心,芬兰
1993 777 距离交流 3,阿姆斯特丹,丹麦,Sovakia,德国,莫斯科,雷克雅未克

博物馆收藏
雷克雅未克市艺术博物馆,冰岛
艺术中心,挪威
当代艺术博物馆,冰岛
现代艺术博物馆,纽约
国家艺术博物馆,冰岛
国际邮政艺术档案馆,意大利
艺术博物馆,芬兰

获 奖
1986 获国际空间站大楼雕塑大赛一等奖,冰岛
1989 获瑞典皇家"女王奖"勋章
1989 获"第七届国际艺术大赛"雕塑优秀证书,纽约
1994 户外雕塑大赛一等奖,雷克雅未克

RÚRÍ

Born in 1951in Reykjavik.Lives in Reykjvik. Studied in Iceland and the Netherlands. Has lived and worked in the Netherlands, Demark, Finland and Sweden.

Selected Solo Exhibitions

1977	Solstice, Flatey, Brei ð afiri ð, Iceland
1978	De Appel, Amsterdam The Netherlands.
1979	Gallerie Lóa, Amsterdam
1982	The Living Art Museum - Nylistasafni ð, Reykjavik
1983	Earthpoem I Korpulfsstagir, Reykjavik
1989	Fragments of Time, Konstakademien, Stockholm, Sweden
1992	Relativity, The ReykjavikMunicipal Art Museum - Kjarvalssta ð ir
1994	Values, Kuvataideakatemian Galleria, Helsinki, Finland
1998	PARADISE? - When? The Reykjavik Municipal Art Museum - Kjarvassta ð ir
1999	Passing of Time, Ketilshúsi , Akureyri, Iceland

Selected Group Exhibitions

1974	Reykjvik Sculptors, the Reykjavik Arts Festival, Iceland
1978	Studio Levi, Madrid, Spain
1979	Gallerie Zona, Florence, Italy
1980	Bregfirgingabuo, The Reykjavik Arts Festival.
1980	Experimental Environment II, Korpúlfssta ð ir
1981	Performance, the Henie-Onstad Art Center, Hð vikodden, Norway
1982	Biennale de Paris, Beaubourg, Paris
1983	Across the Meridian, Museum Fodor - Stedlijk Museum, Amsterdam
1983	Biennale de Pontevedra, Pontevedra, Spain
1986	Concrete, Helsinki Art Festival, Finland
1986	Sculptures for Airport, Kjarvalsstagir, The Reykjavik Municipal Art Museum
1988	1st.International Mail - Art Exhibition , Pontevedra, Spain
1989	Traffic, Stokkholms Stadsmuseum, Stockholm
1990	Art/Nature, Genoa, Italy
1995	The Living Art Museum 17 years, the Living Art Museum, Reykjavik
1996	Altitudes, Artemisia Gallery, USA
1997	The Living Art Museum, from Collection, Reykjavik
1998	Chicago Art Fair, Chicago, USA
1999	Stockholms Art Fair 1999, Speiial exhibition, Vidoe Projections, Stockholm, Sweden
2000	Dialogues with the Collection, The Living Art Museum, Reykjavik

Museum / Collection

The Reykjavik Municipal Art Museum - Kjavalssta ð ir, Iceland

The Henie - Onstad Art Center, H ö vikodden, Norway

Nylistasafni ð the Living Art Museum, Iceland

The Museum of Modern Art, New York

The National Gallery of Art, Iceland

International Mail Art Archive, Pisa, Italy

The Kuopio Art Museum, Kuopio, Finland

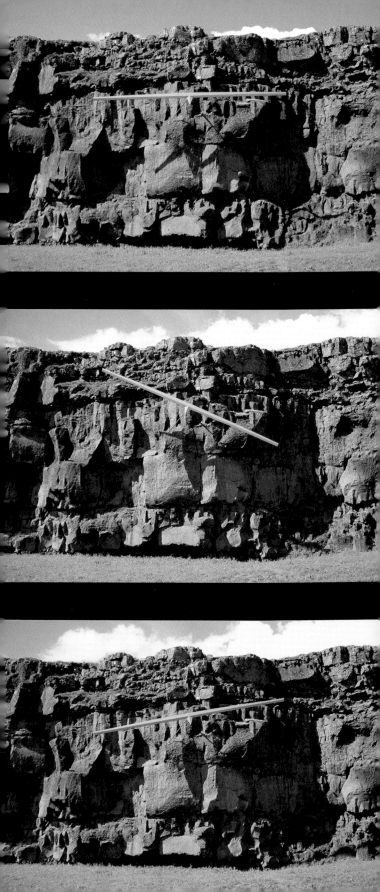

《适 度》
2000

　　这件艺术作品的设计对适度的古典效能作出阐释。适度，或者为极端之间的平衡是一个基本的性质，它也展示了所有其他的效能。因此这件艺术作品是关于平衡的建构。

　　通过一个中心轴把作品的每一部分系在被固定在悬崖壁上的一个钢架上。遇上好天气时，艺术作品显示出水平线完美的平衡。但是，哪怕是极微弱的风也会干扰它的平衡，使其来回"转动"。由于作品朝轴心转动，它的运动是缓慢和有浮力的，因为在外壳里面带有一个复杂的机械装置。在轴心下面有一个内装砝码的直角形使作品最后返回到平衡的位置。

　　艺术作品是为"古代与现代的七种效能"展览而创作的。有 14 位艺术家根据各种效能进行了创作。该展览是冰岛基督教 1000 年的一个大型庆祝节的一部分。庆祝节在 Thingvellir 举行，它地处冰岛的一个清水湖，此地也是欧洲最古老的民主政府的基金会。

　　材料：玻璃钢，不锈钢，铅，铝，滚珠轴承，清漆。

　　色彩：深金色

　　结构长度：1 000 厘米

　　高度：60 厘米

　　厚度：11.5 厘米

　　离地高度：7 500 厘米

　　作品与悬崖壁的相隔距离：100 厘米

Moderation
2000

This artwork is designed to illustrate the classical virtue of Moderation. Moderation, or the balance between extremes, is a fundamental quality and is exhibited in all other virtues.

The artwork is thus built around balance.

The piece of art is attached through a central axis to a steel bracket that is fastened to the cliff-wall. When the weather is still the artwork is in perfect, horizontal balance. However, the faintest breeze disturbs the equilibrium and starts it "rolling" back and forth. As the artwork turns on its axis, its movement is slow and buoyant, owing to a sophisticated mechanism contained within the outer shell. After a time, a weight built into the triangular shape below the axis eventually brings the artwork back into a state of balance.

The artwork was made for the exhibition "The Seven Virtues in Ancient and Modern Times" where 14 artists made their contributions based on the various virtues. The exhibition was a part of a large festival celebrating 1000 years of Christianity in Iceland. The Festival took place at Thingvellir, the site of both the largest fresh water lake in Iceland, and of the foundation of the oldest democratic government in Europe.

Material: Fiberglass (fiberplastic), stainless steel, lead, aluminium, ball-bearings, varnish

Colour: Dark gold

Length of the construction: 1 000 cm

Height: 60 cm

Thickness: 11.5 cm

Height above ground: 7500 cm

The distance from the cliffwall: 100 cm

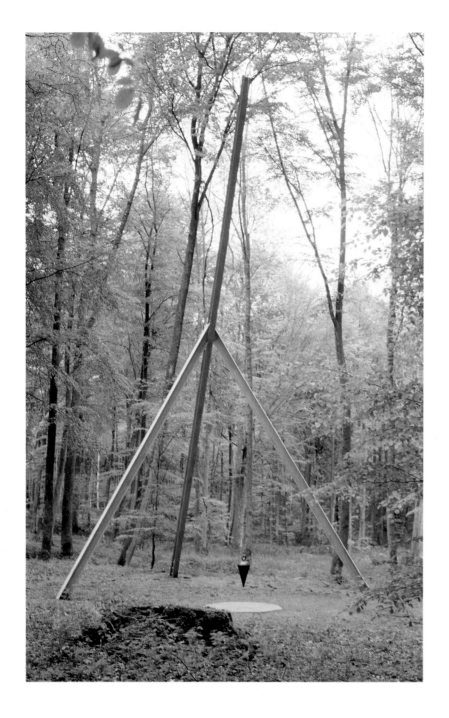 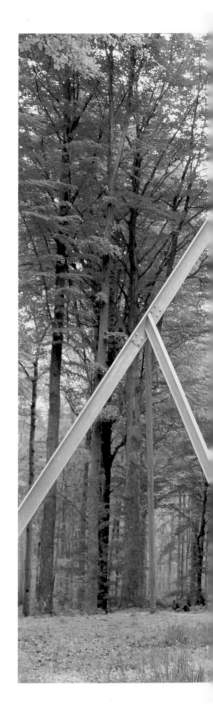

《观测》

 材料：电镀钢、铸铁、钢丝、花岗岩

 尺寸：10.6 米×6.75 米×6.75 米

 地点：瑞士森林

 创作时间：1992 年

 作品安放在森林里一个清洁的自然环境中，工具和设备是用现代材料和设备制作的，但观念取决于古代科学。

 雕塑外形由三个大的钢棍构成。一个很重的铸铁，从最高的横梁上挂下来，指向地球、宇宙和无限的中心

 横梁的结构显示了在冬至日落和在夏至日出的方向。朝向基本点的方向被刻在一个很小的直接在铅锤之下的花岗岩石的平台上。

 结构本身包含一些纯粹的数学信息：60 度角、45 度角、90 度角，以及平面三角、六边形，垂直线、地平线等。

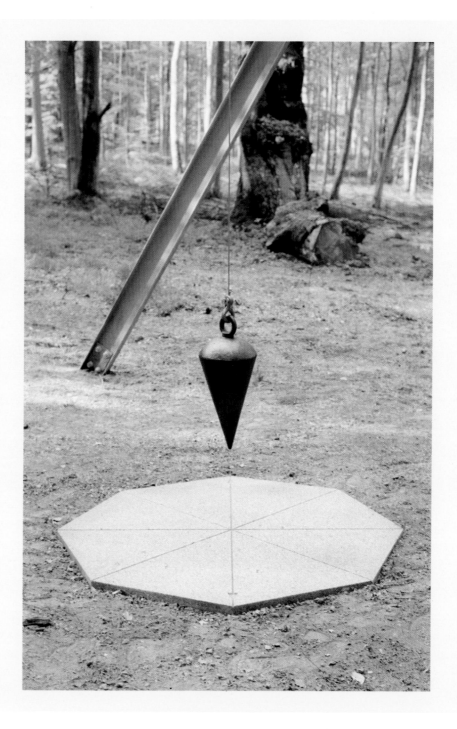

Observatorium
1992

The sculpture was made for the Wanas exhibition in Sweden, and is placed in natural cleaning in the forest. It is a tool or equipment made with modern materials and techniques, but based on ancient science.

Materials: galvanized steel, cast iron, steel-wire and granite.Measurement: 10.6 ×6.75×6.75 m.

Three large steel beams form the outline of the sculpture.

A heavy cast iron plumb, hanging from the tallest beam, points towards the center of the earth, while the wire it hangs from leads the eye towards the sky, the universe and infinity.

The beam construction shows the directions towards the sunset at winter solstice and to the sunrise at summer solstice. Directions to the cardinal points are engraved in a small granite platform directly below the plumb.

The structure itself includes some pure mathematical information: 60 degree angle, 45 degree angle, 90 degree angle, even sided triangle, hexagon, vertical and horizontal lines and more.

《天堂？—什么时候？》

创作时间：1998 年。

该作品的形式是装置艺术，在雷克雅未克艺术博物馆展出。占据空间为 500 平方米。装置内容由下列设备和物件组成：一个播放三个摄像的电影场地，在三面墙上并行播放来自波斯尼亚·黑塞哥维那的电影。一个记载在武装冲突中人员下落不明的 100，000 张目录卡片的系统。一个摄影区，一个电脑区，在钢架上的丝绸银幕，以及其他。

《天堂？—什么时候？》是系列组合形式的一件艺术作品，在一个环境中放置和使用了多种不同的材料和技术。展览在庆祝联合国人权声明签署五十周年的时候举办。该展览应当被看做是一个致力于为世界和平而争辩的国际艺术家的贡献。通过敏锐的感觉，艺术家们也许能更加清晰和更有意识地阅读和理解时间的符号。他们总是立足于和平和自由。

Pradise?-when?

1998.

More than exhibition, this a unified work of art, an environment in which numerous and diverse materials and techniques are put to use. The exhibition is held at the same time as we mark the 50th anniversary of the signing of the UN Declaration of human Rights, and should be regarded as a contribution by an international artist of high repute to the worldwide peace debate. Artists, who perhaps through their seismographic capability of perceiving can read and understand the signs of the times more clearly and more consciously, have always taken up the cause of peace and freedom. They have supported Amnesty International, stood up for the maintenance of human rights through visual means. And demanded the preservation of human dignity with regard to the victims of violence and destruction. One could mention, for example, the worldwide project Artist Against Torture as well as innumerable efforts on the part of individual artists. Fears of destruction are the central focus here, especially the threat posed to man by humanity.

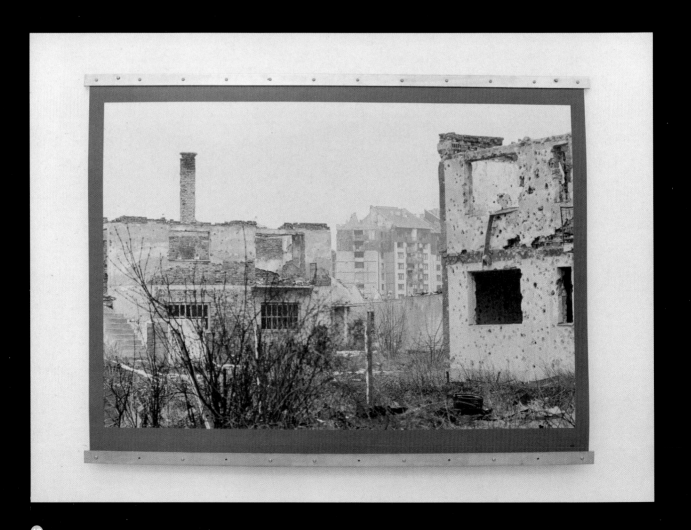

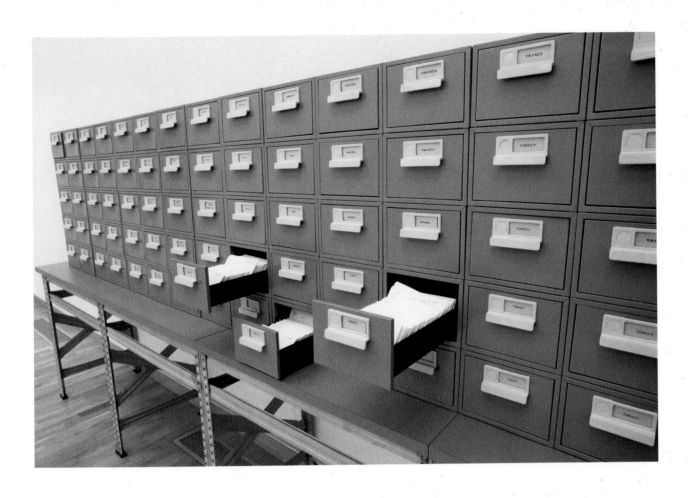

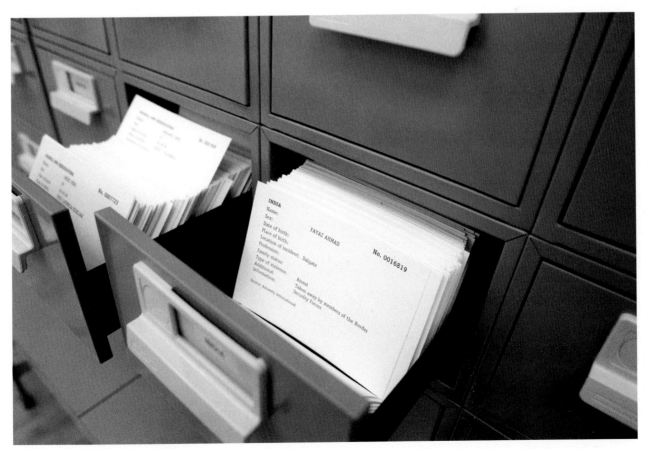

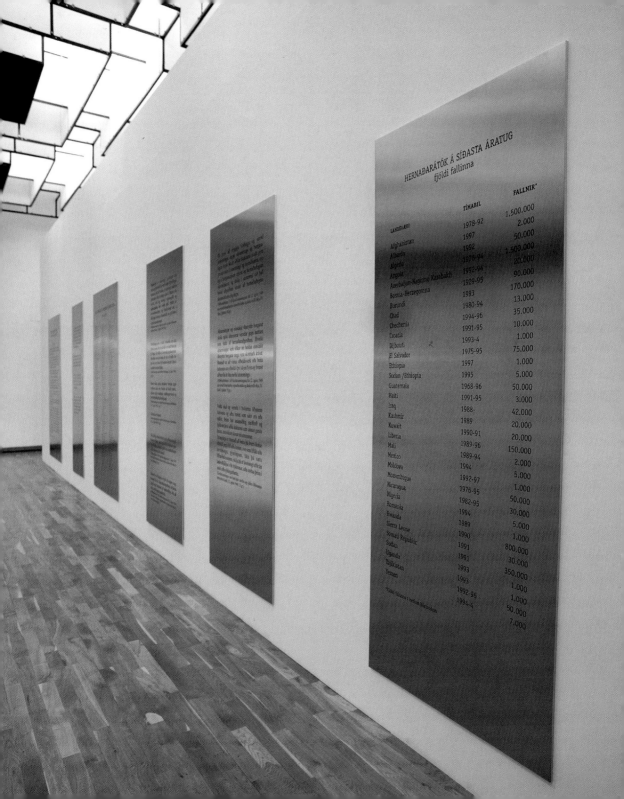

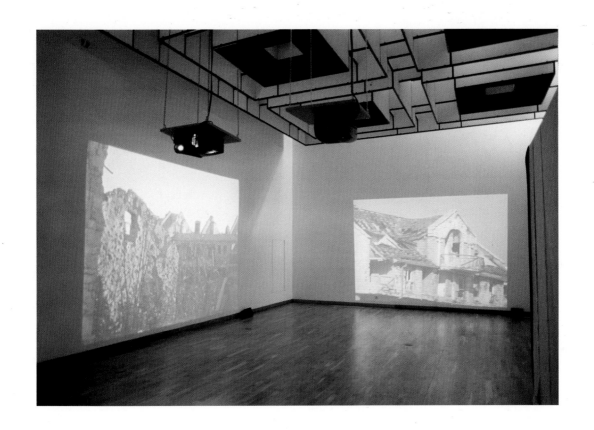

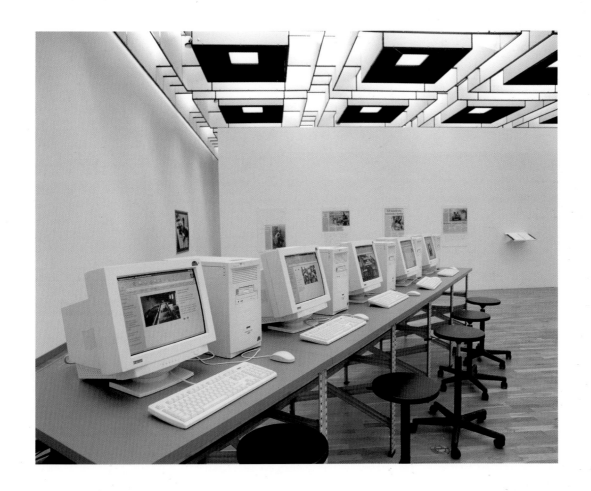

《彩虹》

　　材　　料：不锈钢，染色玻璃
　　总 高 度：24米
　　地　　点：冰岛雷克雅未克国际机场
　　创作时间：1991年。

　　"彩虹"在古老的斯堪的纳维亚神话中具有一种象征意义。在 Snorra Edda（北欧文化古书中，它被称做（Bifrost），可以翻译为"移动之路"。据说它是神灵可以去上天或天堂的一座桥。推测神灵在天堂有自己的居所，桥由神灵之一所牵引。

　　冰岛民间传说中的彩虹的象征意义与好运或希望有关。故事中讲到，如果有一个人站在彩虹下，他也许会有一个希望——在将来得以实现。

　　一个相类似的和广为人知的欧洲说法中讲到，如果有一个人能到达彩虹，他会在彩虹之下的末端发现运气。在后来的说法中，运气被看作充满黄金或者财富的一口大锅。此情形下的民间传说失去了它更深的意义，因为这忽视了对运气作为庄严和好运——就像"走运"一词中含有的神秘性——的转化。

　　彩虹的神秘含义可以是"照明之路"，一个人必须经此路以获得智慧而且使精神得到发展。一条途径或者道路可以被证明为既艰难又复杂，要试着前行。站在彩虹中间下面的一个人的视觉形象可以被理解为：一个高度发展的个性或心灵精神的神秘象征。个人的光辉获得的如此强大的力量，明亮和规模，宛如一道彩虹。

The Rainbow Reflections

The rainbow has a symbolic meaning in Old Norse mythology. In Snorra Edda (the ancient book of Nordic culture) it is called Bifrost, which could be translated as "he road that moves" It was said to be a bridge to the sky or the heavens that the gods could ride. Presumably the gods had their dwellings (Agarour) in heaven, and the bridge was guarded by one of the gods.

In Icelandic folklore the rainbow has a symbolic meaning in connection with good fortune or wishes. The story tells that if one can stand "nder the rainbow" one may have a wish, that will be fulfilled.

A parallel and more widely known European version tells that if one can get to the rainbow one will fine a fortune under its end. The fortune in the latter version is referred to as a cauldron full of gold, or wealth. In this case the folklore has lost its deeper meaning by ignoring the esoteric translation of fortune as destiny and luck, as in "ood fortune"

The esoteric meaning of the rainbow could be the "lluminated path" one must travel in order to gain wisdom and to develop spiritually. A path or road that can prove to be both hard or soul. The aura of the individual has gained such strength, brilliance and size that resembles a rainbow.

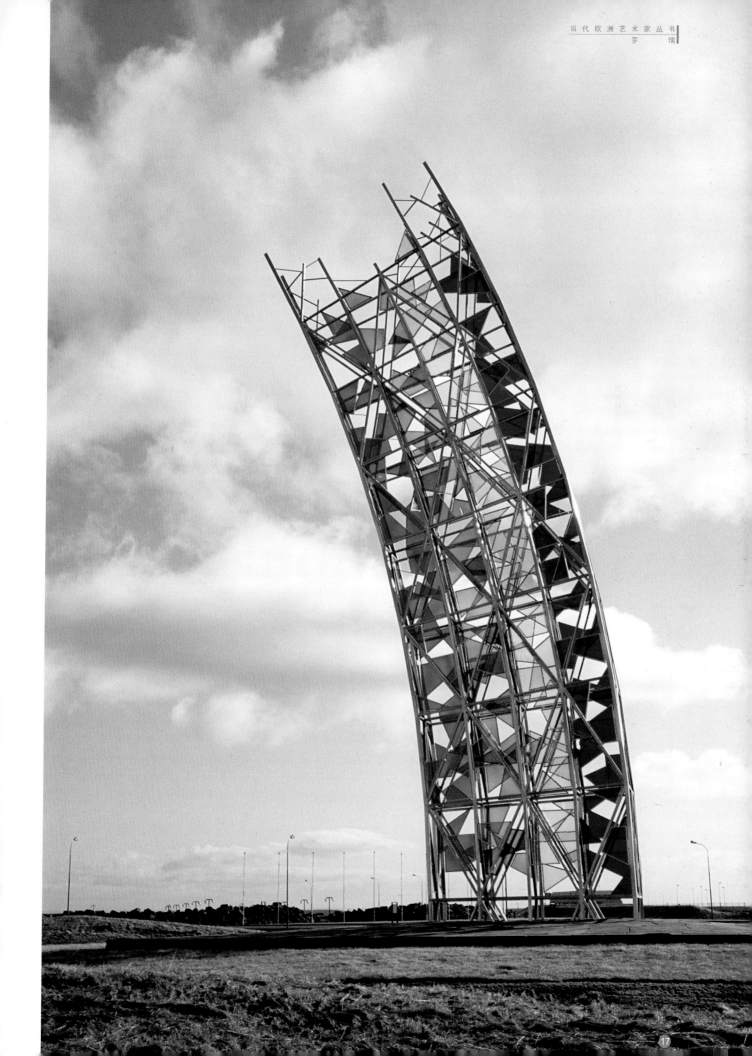

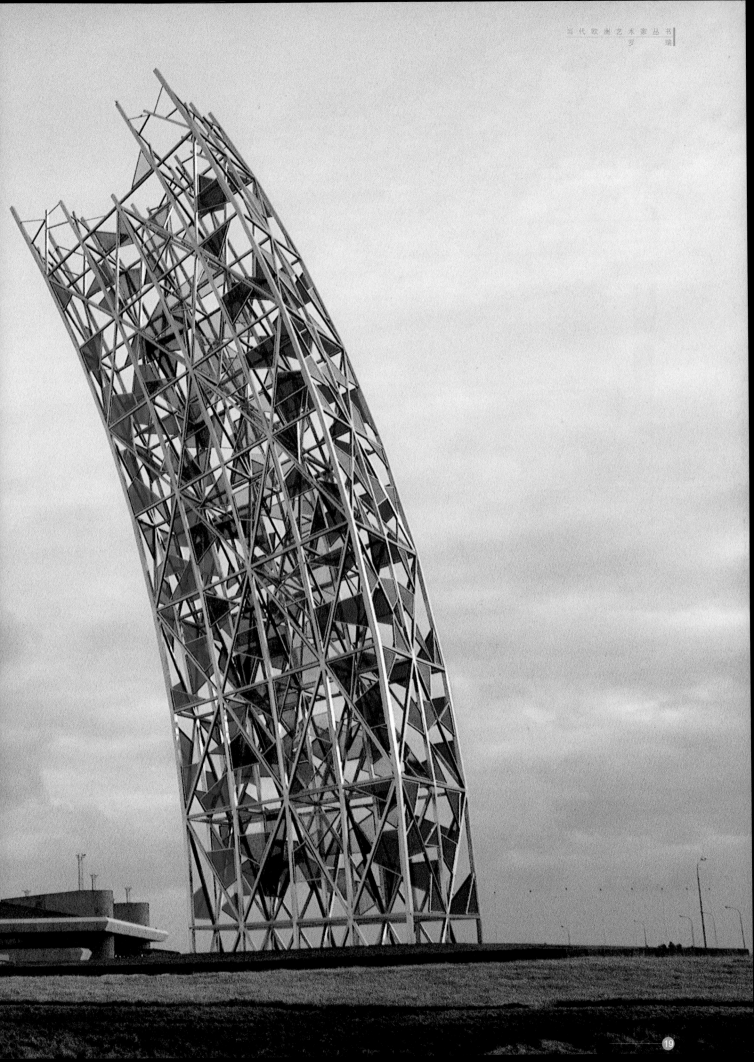

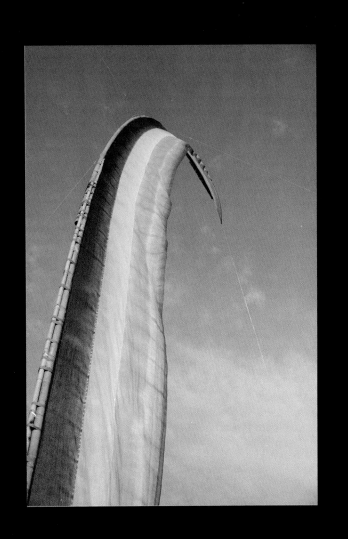 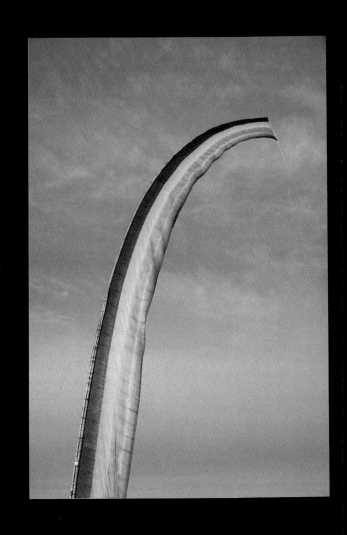

《彩虹》之一

　　创作时间：1983 年

　　材料：手绘的纺织品和竹子，17 米

　　作者在靠近海边的冰岛外景处竖立了一道"彩虹"，这是一个以彩虹的色彩秩序画在布上的一个细长的结构。然后她在"彩虹"的底端部点上火，顷刻间，"彩虹"在火光中消失。

　　不管作者为点燃所选择的材料是多么的简单——有时近于平淡无奇，但是它们总是被赋予一种抒情的特质。

Rainbow I, 1983. Sculpture - film.

Linen, Bamboo. Height 17m.

Reykjavik

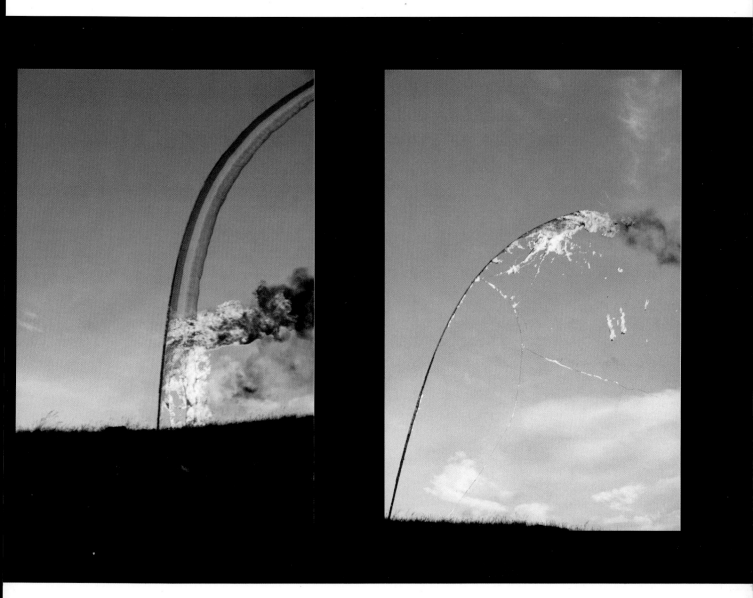

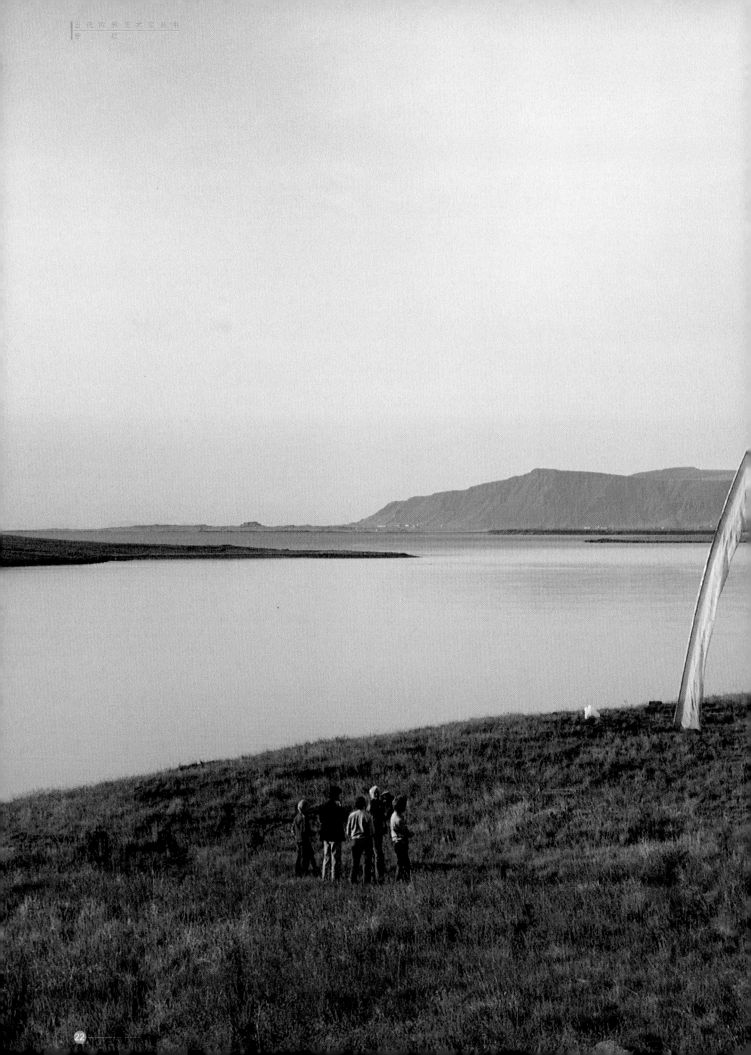

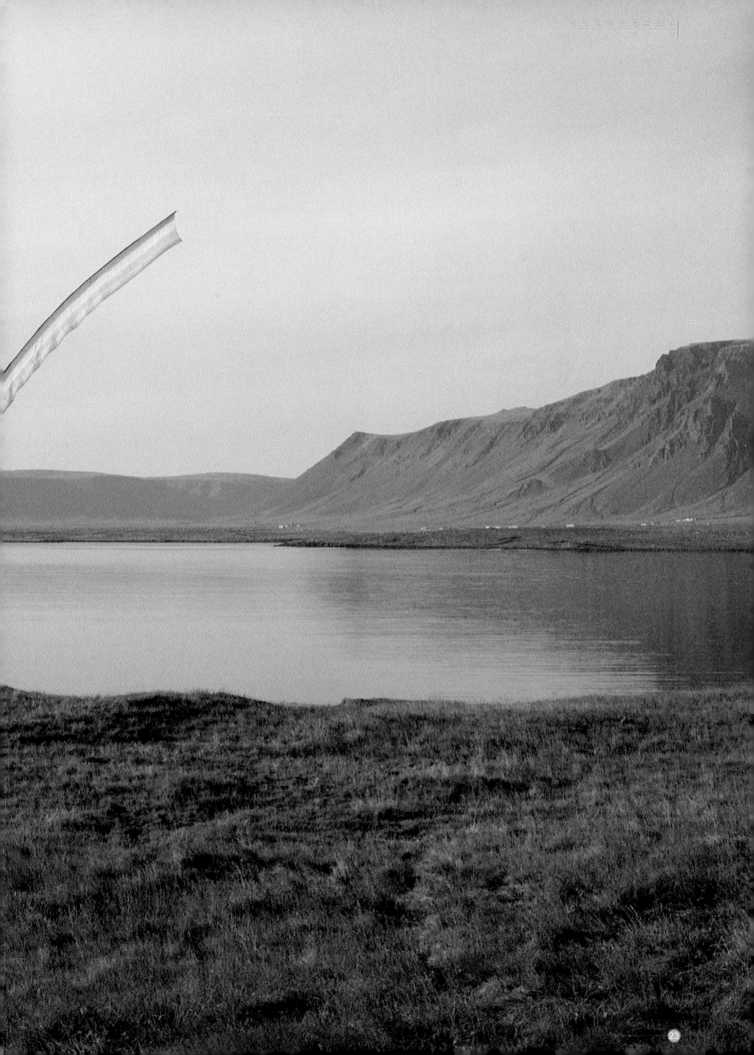

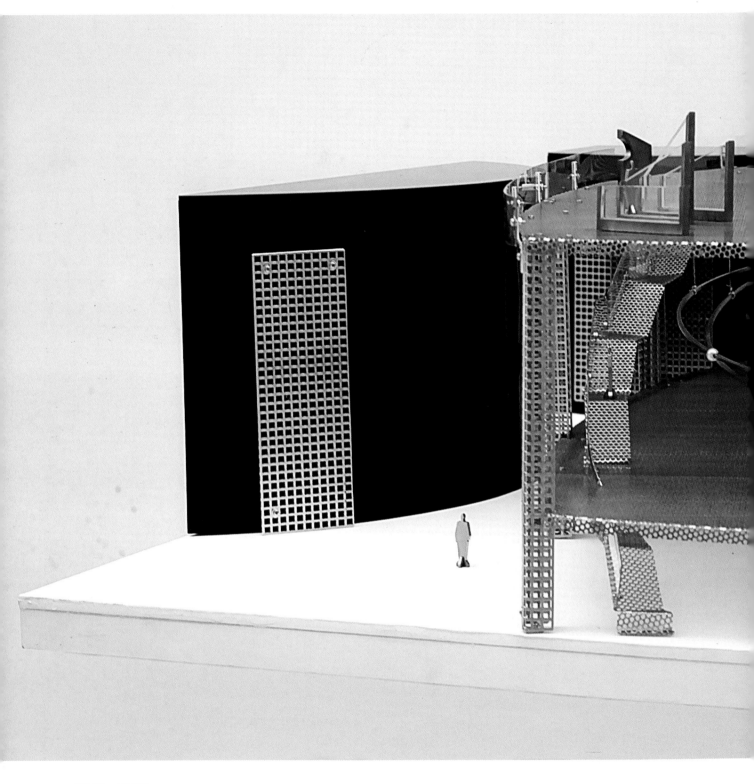

《地球—宇宙》
2000 年

为世纪之交所做的装置展览的一项计划。

在地球和各种天体之间，地球在宇宙中的（时空）位置和在这个庞大的天象图之中的人类的位置是这件艺术作品的主题。作品《地球—天体》的设计既是太阳天文台，又是一个太阳系统的模型。

模型的制作是按照在冰岛的雷克雅未克的位置上的经度和纬度的关系计算出来的。城市靠地热水取暖。热水是靠六个巨大而且看上去不美的蓄水罐（高 13.5 米和直径 30 米）储藏的。它们位于最初属于城外的一个山丘的顶端。但是，随着城市的迅速成长，目前一个新的生活区域正在山丘的斜坡上建设起来。储水罐以一个椭圆形包围着一个空荡的场地，穿过一条长长的中线，全长为 67 米。装置的计划是按照这个空间设计的。

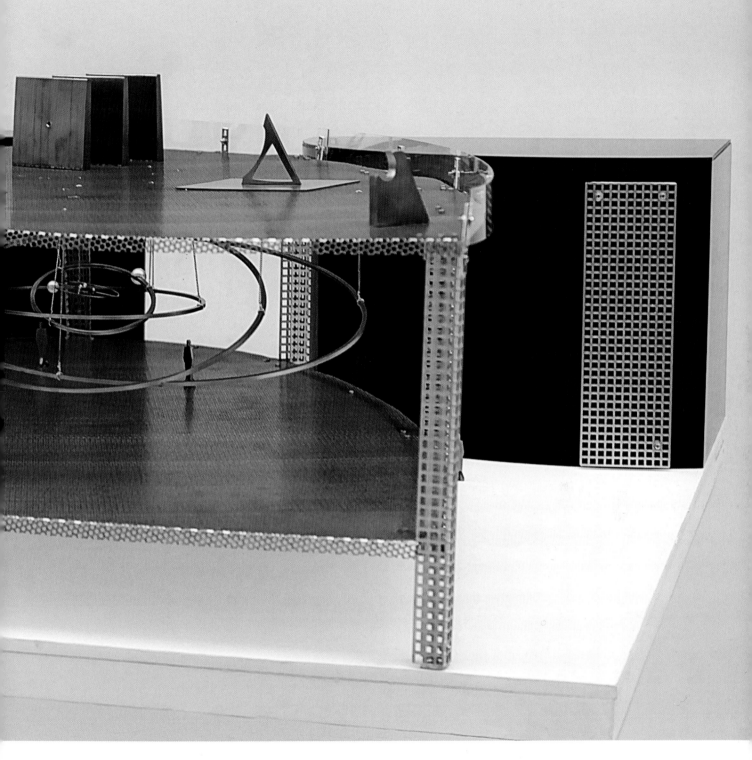

　　在我们的太阳系统的一个复制品里面，在两千年（在雷克雅未克）来临的确切时刻，星球在它们的椭圆形的通道位置上将精确地回应于真正的太阳系统。这是最精确的方法，适用于对宇宙范围的无限时间中的某一时刻做出解释。

　　由三堵墙组成的一个联体是一个设备，这是用来捕捉在春分的时刻太阳升起时的阳光辐射。在那一时刻，太阳的位置与在同一时间星星正在天空的背后升起形成联系，这是用来在一个巨大的时间刻度上对一个新纪元做出的解释。

　　艺术作品的其他联体是"中午时分的太阳"、一个"太阳刻度盘"和"东北至西南的线体"。最后一件涉及到东北至西南的线呈现在一年的时间跨度时的古代时间，一个太阳的寿命以及一个人的寿命。在夜间，装置会被一个呈蓝色的光线微弱地照明，但是当星星闪烁的时候，照明可以被关掉。

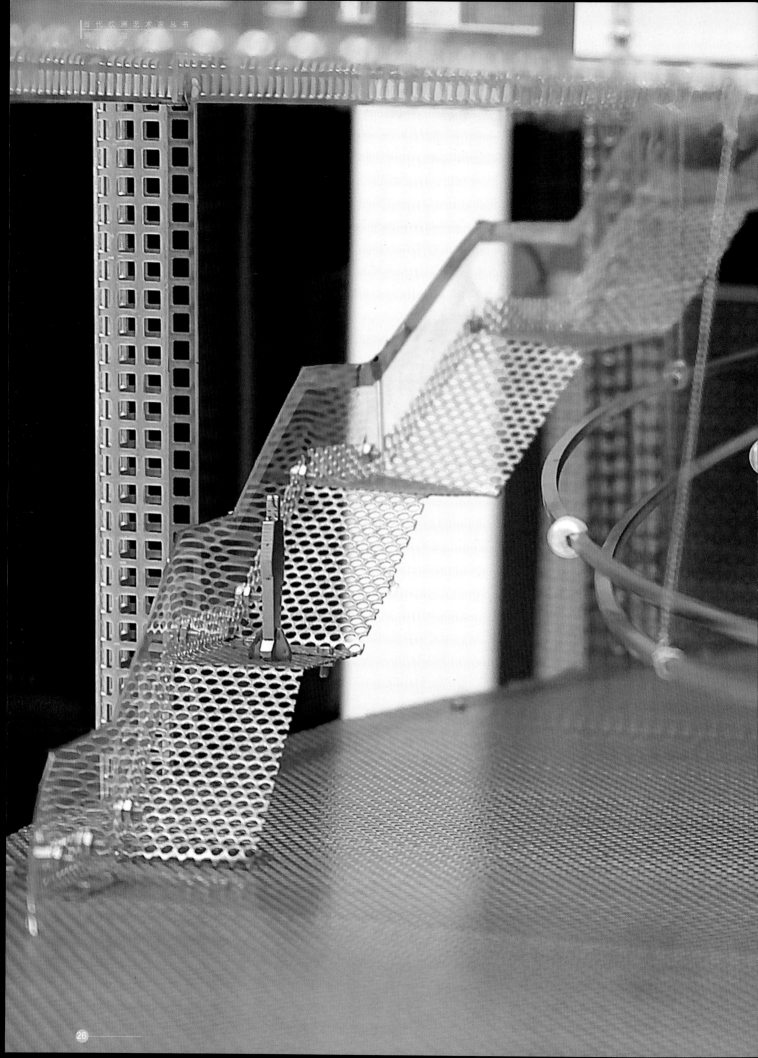

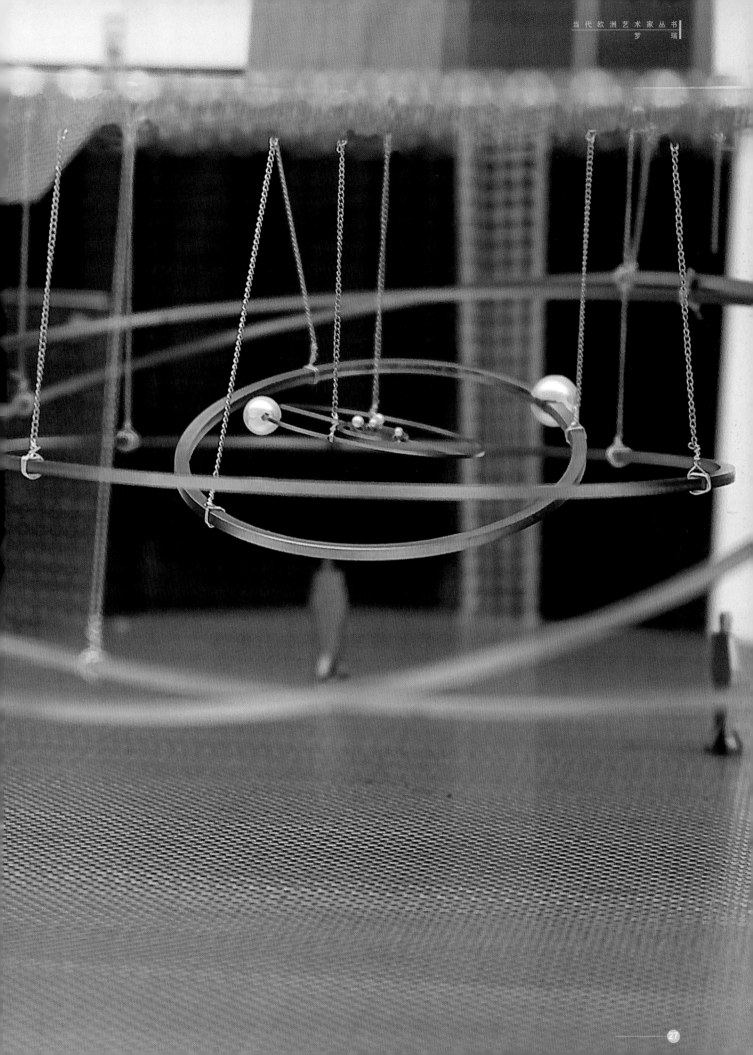

模型的大小比例为 1：50。模型不展示整个装
置,仅仅是蓄水罐体周围的局部。艺术作品仅仅
作为一个模型存在。

Terra -Cosmos
2000

A theoretical plan for an installation for the turn of a
millennium.

The relationship between the Earth and the various
heavenly bodies, the location of the Earth in the
Universe (in time and space), and the position of hu
man beings within this large scheme is the theme of the artwork.
Terra-Cosmos is designed to be both an observatory for
the sun, and a model of the Solar system. The model is
calculated in relationship to the longitude and latitude
of Reykjavik in Iceland. The city is heated by geothermal
water. The hot water is collected in six large and unat-
tractive tanks (13.5 meter tall and 30 meters in diameter)
that stand on the top of a hill that was originally outside
the city. However, with the rapid growth of the city, a
new living area is now being constructed on the slopes
of the hill. The tanks surround an empty space in the
shape of an ellipse, a total of 67 m. across the long axes.
The installation plan is designed to fit this space.

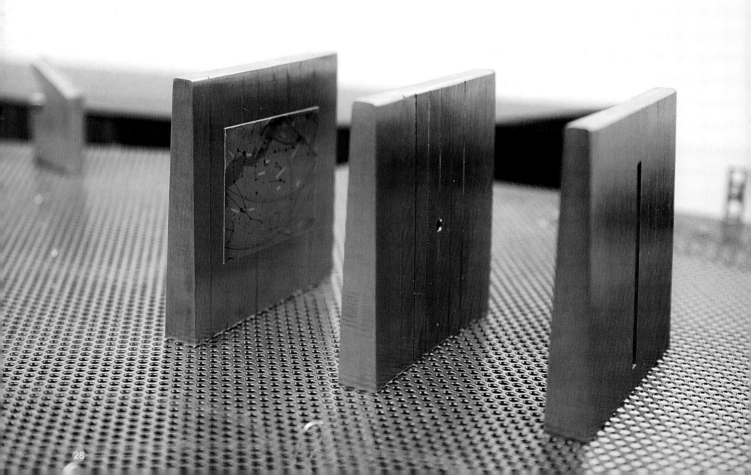

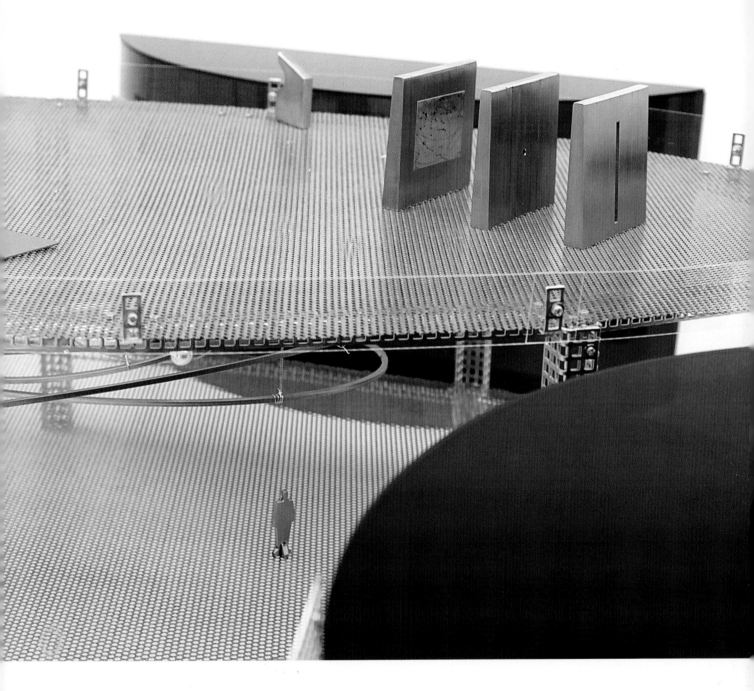

In a replica of our Solar system, the position of the planets on their elliptical paths will precisely correspond to the positions of the real ones at the exact moment of the turn of the two millennia (in Reykjavik). This serves as the most precise method to define that moment on the vast time scale of the Universe. A unit which consists of three walls is a device designed to capture the rays of the sun at sunrise on the Spring Equinox. The position of the sun at that moment in relation to the stars that are rising at the same time in the sky behind it is used to define an epoch on a large time scale. Other units of the artwork are"Noonday Suna Sundial" and the "Line North-East to South-West". The last one refers to ancient times when the line NE-SW represented the span of one year, the lifetime of one sun, and the lifetime of a human being as well.

At nighttime the installation would be faintly illuminated with a bluish light, but when stargazing the illumination could be turned off.

Model scale: 1:50. The model does not show the whole installation, and only fragments of the surrounding tanks. The artwork only exists as a model.

《混凝土的时光》
1986 年

该作品创作于 1986 年，参加在芬兰举办的"混凝土展览"。该展览是艺术节的一部分，也是进行环境实验的一个项目。

技术:用一种特殊的混凝土铸造，尺寸:4.5 米×13 米×5 米 (高，长，宽)。

雕塑或装置的造型是依据背后的建筑而创作的，该建筑位于 Iso Rovertinkatu 的东部。在 Helsinki 的许多老建筑物的建筑风格中，该建筑是颇有特点的。艺术作品以两个不同时期的建筑内格来进行造型，它们都体现了未来状况的可能性。

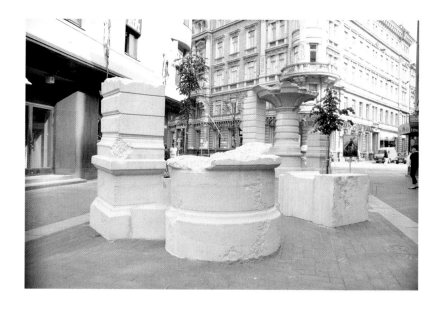

时间是永恒的，

无论有人关注与否

它都在继续，

变化和改变着环境以及存在。

然而，时间不是均匀的。

它受之于情景

心灵和环境的状态

有时急速，有时缓慢。

Time Concrete
1986

Time Concrete was made during the art project and exhibition Concrete, in Helsinki, Finland 1986. The exhibition was a part of the Helsinki Art Festival, and an Experimental Environment project as well.

Tecnique; cast in specially mixed concrete, measurements 4.5×13×5 m (height, length, width).

The sculpture or installation is based on the architecture of a building directly behind it, at the east end of Iso Robertinkatu. The building is characteristic for the architectural style of many older buildings in Helsinki. (The artwork repeats the form of the building in two different stages, which both are future possibilities).

Time is constant,

it continues whether there is anyone

to observe it or not,

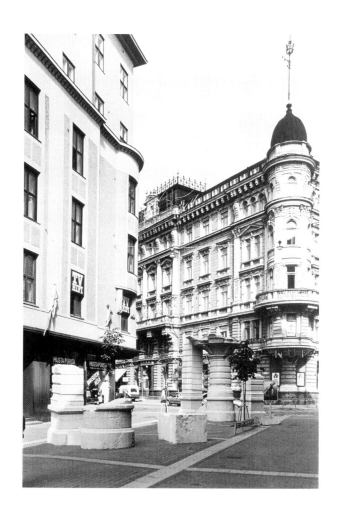

changing and shaping environment and beings.

Still, —time is not uniform.

Sometimes it is fast, sometimes slow,

depending on circumstances,

states of minds and environment.

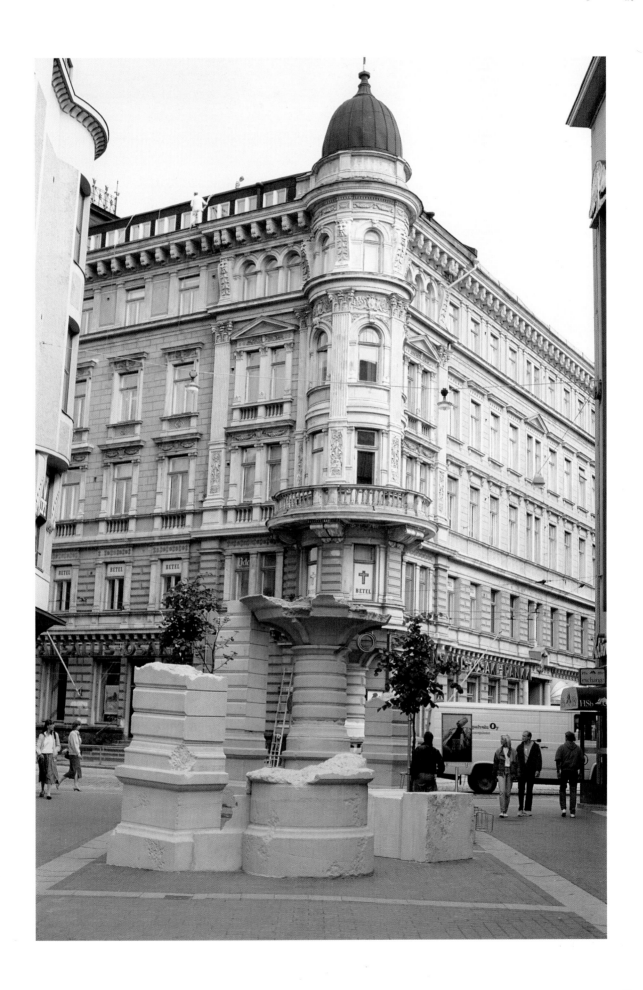

《瀑布》雕塑

材料和技术：涂颜料的水泥，水，水泵，电脑，光。高度：360 厘米，长度：2500 厘米。

创作时间：1995 年。

两个深蓝色的石柱并列矗立于地面的一个放满水的狭小的水池中，石柱之间有一个狭长的空隙。水从石柱空隙中流出，而且从石柱顶端蔓过。有一部电脑控制水的流量。水的流速时快时慢，一直发生变化，有时像很有气势的瀑布。该策划包括一个偶然性因素，即增加水的形状变化。环绕在石柱周围的水池深度为三米。水层的"裂缝"也在发生变化。水流向水池时发出声音，水池被当作"音箱"，水发出声音变化的频率随水的深度而产生。

水力的最低点为 120 厘米，被当做人工饮水泉。当有人走近时，过道震感器便开始自动流出新鲜水，稍过片刻会自动停止。

水力的最小点是两个石柱和水池。深蓝色的石柱沿着地面裂缝方向形成一个线形裂缝。

控制水流的技术设备被安放在靠近水池的一个地下室里。设备包括：一部 IMB 电脑和一部巨大的工业电脑，13 个水泵和震感器。每一个水泵受到分别控制。

水流受天气变化的影响，因为电脑与风速和气温的震感器相连接。

Waterfall
1995

Located in the Botanic Garden of Reykjavik.

Height 660 cm (360 cm above ground level and 300cm below ground level), length 2500 cm,whicth 800cm.

Technique: pigmented concrete, water, water pumps, computers, light.

Two columns dark-blue columns protrude from a narrow split in the ground that is filled with water. Water spurts between the two columns, and also flows over their tops.

A computer controls the flow is constantly changing, sometimes the water falls very quietly and sometimes it is like a powerful waterfall. Included in the program is a random factor thus increasing the changes in the pattern.

The basin surrounding the two columns is 3 meter deep. The level of the water in this "issure" is changing too. The water filled basin serves as a "ound box" the frequency of the sound varying with the depth of the water.

A low element (120 cm) serves as a drinking fountain. When someone approaches it a vibration-sensor in the pavement starts the flow of fresh water automatically, and after a while cuts it off again.

The small element, the two columns and the basin, and blue stones in the pavement form a line or "issure" in the direction of the fissures in the earth crust in Reykjacvik.

The technical equipment that control the water flow is housed in an underground room that was built next to the basin. The equipment consists of an IMB computer and a huge industrial computer plus 13 water pumps and sensors. Each pump is controlled separately.

The water flow is influenced by the weather at time, as the computers are connected to sensors for both the wind velocity and for the air temperature, that are installed in the neighborhood of the artwork.

Once in a while I write some new programmers for the water flow on my computer, that are then added to the mother computer in the control room.

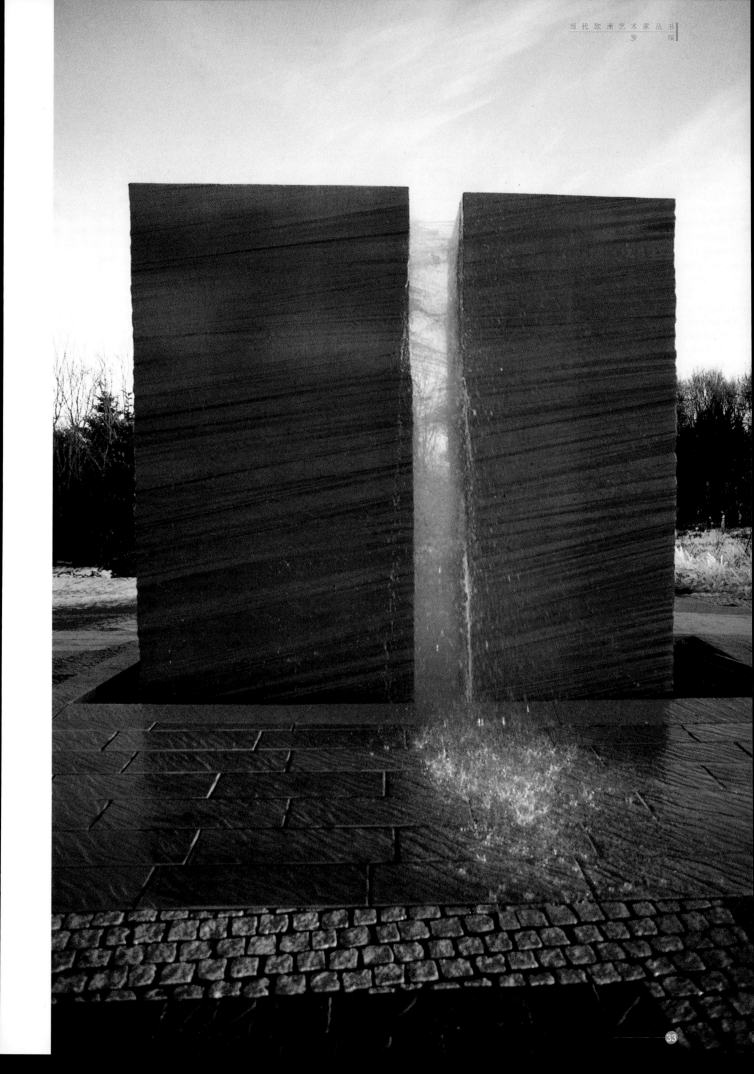

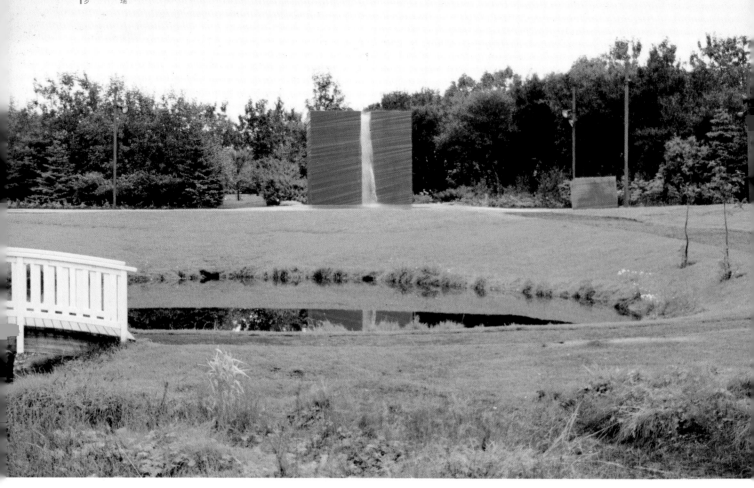

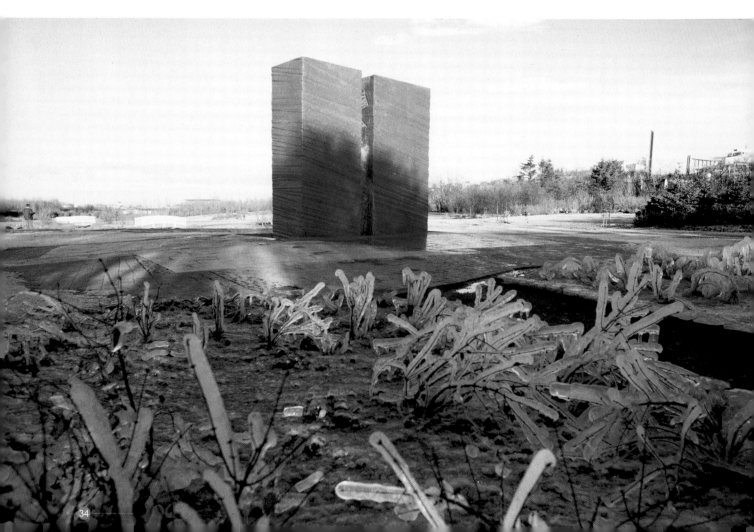

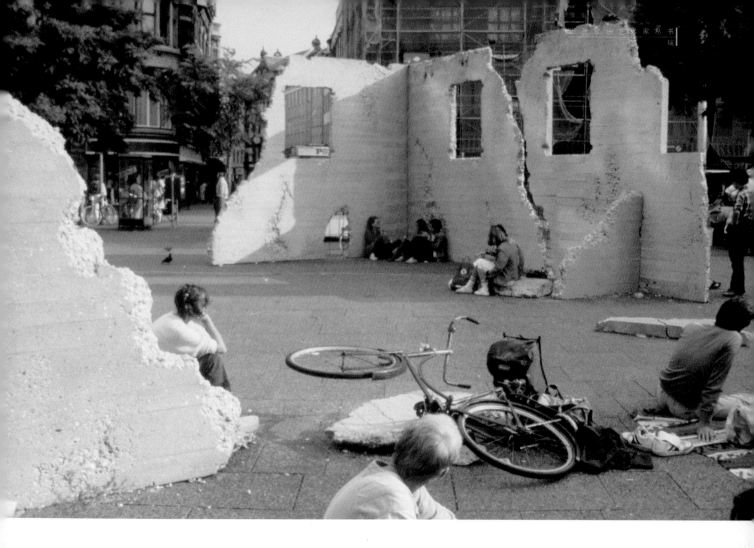

《废 墟》
1984 年

《废墟》创作于 1984 年在丹麦哥本哈根举办的《瞬息即逝的水泥》艺术设计展览。

材料: 标准水泥, 尺寸: 4 米×11 米×10 米.

前不久我路经一片废墟。

当我在其中前行时,

我发现这不仅是几座房屋被毁

而是一个保留完整的小城。

这里有街道, 路灯,

运输卡车和码头。

现在惟有一片废墟。

雕塑主要依据该城市主要建筑的毁坏部分。该城市主要用水泥材料建造。

《瞬息即逝的水泥》是在 1979 年一个斯堪的纳维亚艺术家群体开始发起的室外环境设计实验。这是把大地艺术的符号转入一座城市的一次实验。这座城市环境成为 12 名艺术家进行创作的地方。在这一环境中最自然的材料, 也是最重要的因素就是水泥。

当我为这一项目寻找思路时, 我开始从过去, 现在和将来的前后关系, 以及对一座完整的小城的毁坏, 以前我看到的和在我心中留下的记忆来把握城市的现象。我拍下这些损坏的城市并记下它们的尺寸。由于我不想为雕塑设计想像中的损坏形象, 我感觉这么做太肤浅了, 因此我决定把拍下来的照片当做蓝本。

铸造是在一个水泥厂完成的。当水泥有效地被铸造坚固时, 我用一个重量的空压气锤水泥敲打出整个表层, 然后用沙打磨以获得侵蚀和经岁月风化后的外表。

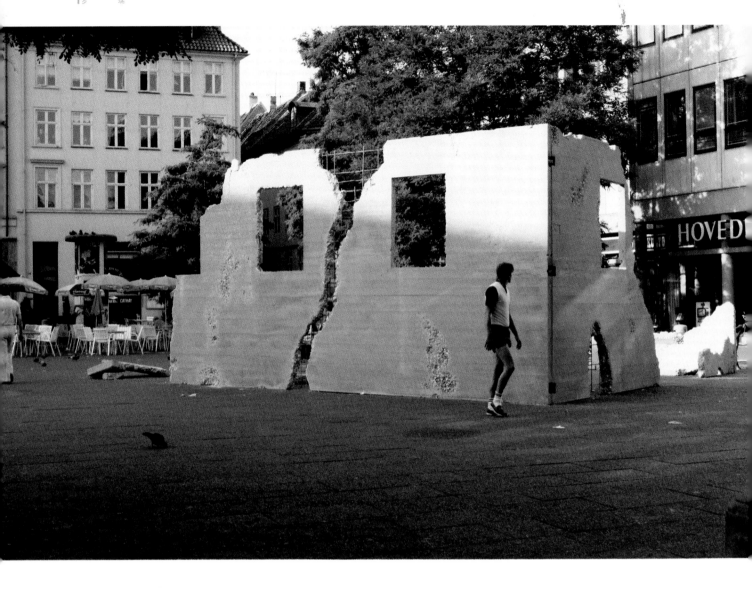

DESOLATION

1984

Desolation was made during the art project and exhibition "Flyvende Beton" Flying Concrete in Copenhagen, Denmark 1984.

Material: standard concrete, measurement 4×11×10m.

Some while ago I came upon ruins.

As I walked among them I realized

that these were not the ruins of a

complete small town.

There had been streets, lampposts

transport tracks and piers.

— Now there was only desolation.

The fly Concrete is one of the Experimental out door projects that a group of Scandinavian artists in 1979. It was an experiment in transporting the land Art notion into a city. The city was the environment in which the 12 artists were to form their artworks.

The most natural material, as well as the most dominating ele in this environment is concrete.

While I was looking for an idea for the project, I started medi on the phenomenon city in a past, present and future contex the memory of some ruins of a complete small town that seen earlier came to my mind. I had photographed these ruin written down some measurements. As I did not want to d imaginary ruins for the sculpture, which felt too superfic decided to use the photographs of the ruins as a blueprint.

The casting was made at a concrete factory site. Whe concrete had hardened sufficiently the whole surface operated with a heavy-duty air compressor hammer, and sand blown to obtain an eroded appearance, and the air of a The artwork was made in several elements, (weighing up t tons each) which later were transported to Kultorvet, pu position and welded together.

Kultorvet is a very busy pedestrian square in Copenhagen.

《方　向》

地点：雷克雅末克南海岸。

创作时间：1998 年

该艺术作品是由四个望远镜组成的装置。放置位置是雷克雅末克的南海岸，望远镜朝向不同的方向。在每一个望远镜的镜头上有一个标题，一个读做"南斯拉夫 3620 公里"。另一个读做"塞拉利昂 6230 公里"。每一个望远镜刚好对准标题方向。

Directions
1998

The artwork is an installation involving four telescopes. They are positioned on the southern sea shore of Reykjavík, pointing in different directions. The lens of each telescope contains an inscription, the first one reading "Yugoslavia 3620 km" while the others say: "Palestine 5280 km", "Mozambique 10360 km" and "Sierra Leone 6230 km"

Each telescope points exactly in the direction inscribed on the lens.

From the exhibition Strandlengjan - The Beach Line, organized by the Reykjavík Sculptors' Society in cooperation with the Reykjavík Arts Festival and "Reykjavík - European Cultural City 2000".

Technique; steel, glass, nylon, varnish, and silk-screen.

The measurements of each telescope: height 144 cm, length 60 cm, thickness 14 cm.

Total length of the entire installation 18 metres.

Directions ⟶

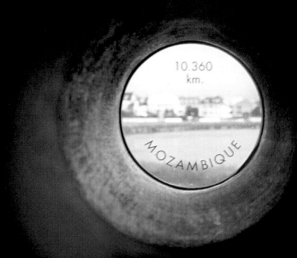

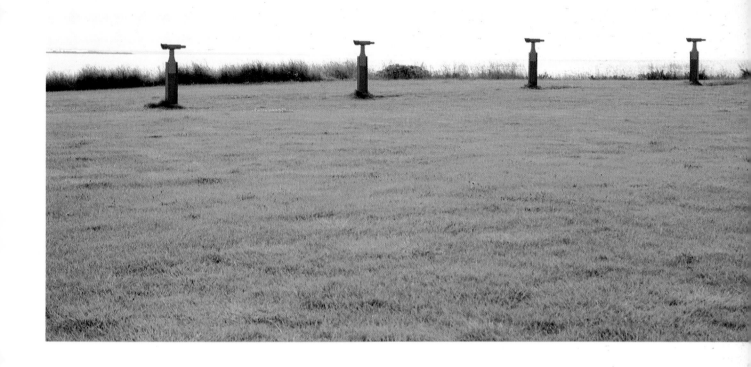

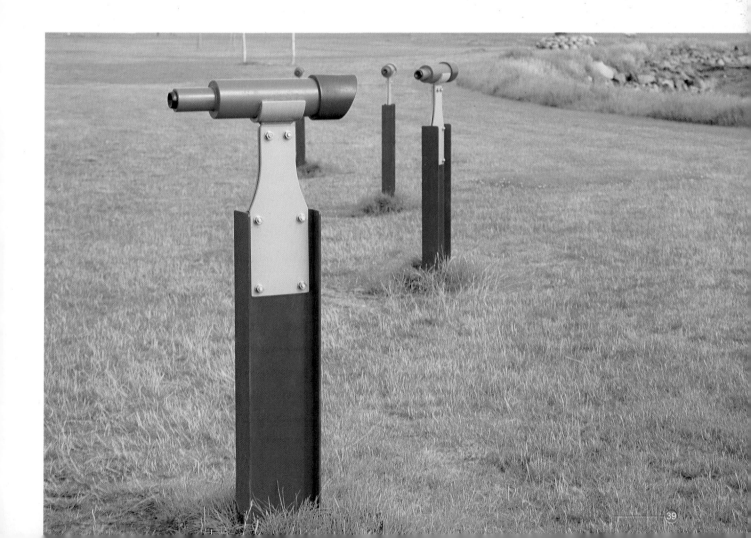

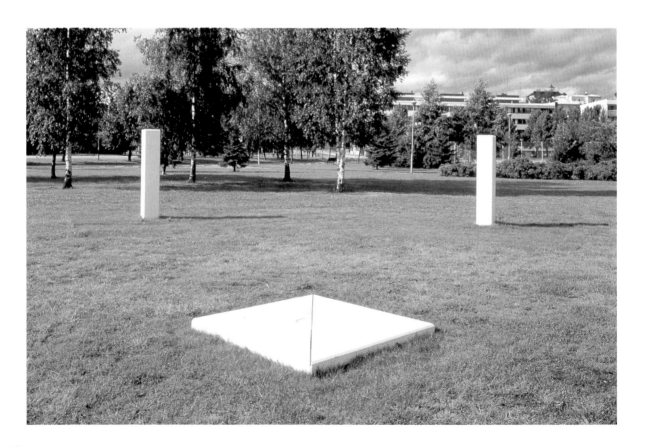

《观　察》

材料：白色水泥，　直径：18.8 米。高度：2 米。地点：芬兰马里公园，创作时间：1995 年。

在材料上可以看到在一年四天中的不同的时间长度。它的立意是，提供观察太阳在这些天的光程。在这件艺术作品中，现代的技术和材料与古代的智慧相结合。

尽可能使用少的材料。六个柱状物暗示地平线的方向和在夏至与冬至的日落，以及从一个小的平台上的"观察点"看到的两分点。

在平台表面的线暗示基本点的方向。从中心点到每一根柱子的距离是九米。柱子的宽度间隔与它们之间阴影的间隔相同。

观察者应当走上平台的中央以便站在观察的准确的位置上。

地平线的日出是每一天真正的开始，地平线的日落表示每一天的结束。作为风景的一个结果，与马里公园的城市布局相联系，由于周围的树林和建筑物地平线的视野极为模糊，因此很少能看到地平线的日出与日落。仅仅朝向东南，湖展示了一个宽广的视野，所以在冬天的一段时节里人在那一方向上能看到日出，而这正是冬至的日出。

柱子的位置是固定的，所以，在夏至，当人从平台上看日出时，面向地平线日出的方向准确地在东南的柱子的右边经过，但只有当太阳升上建筑物，稍稍偏向柱子的右侧之后，才能从公园看到太阳。

以相同的方式，如果地平线的视野不是太昏暗的话，来自左边的太阳会在西北方向的柱子后面的日落中消失。

Kuopio Observatorium

1995

Location Maria Jotuni Park, Kuopio, Finland.

Material white concrete.

Diameter: 18.8 meters.

Height of columns 2 meters.

Kuopio Observatorium visualizes in material the length of four different days of the year in Kuopio. It is a point observing the path of the sun on those days. Modern techniques, and material, and ancient wisdom are combined in the artwork.

The use of material is as possible. Six small columns indicate the direction of horizontal sunrise and horizontal sunset at the summer and winter solstices and at the equinoxes as seen from a small platform "the point of observation".

Lines in the surface of the platform indicate the directions to the cardinal points. The distance from the central point to each column is 9 meters. The columns differ in width and thus their shadows differ.

The observer should step onto the middle of the platform, for exact positioning, while observing.

The horizontal sunrise is the actual beginning of each day, the horizontal sunset marks the end of a day. As a result of the landscape, and layout of the city in relation to Maria Jotuni Park, the horizontal view is mostly obscured by surrounding forests and tall buildings, so that one only seldom see the open view so one can see sunrises that occur in that direction for a part of the winter, and that counts for the winter solstice sunrise.

The columns are positioned so that when looking from the platform at sunrise on the summer solstice the direction towards the horizontal sunrise passes exactly by the right side of the column in the northeast. But the sun will not be visible from the park until a little later when it rises above the building a little to the right of the column.

In a similar way the sun approaching from the left would disappear behind the sunset column in the northwest at the moment of horizontal sunset if the horizontal view was not obscured.

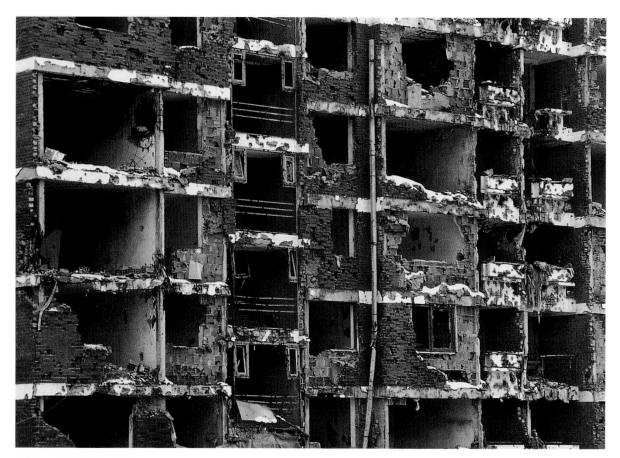

天堂？——什么时候？　1998
Paradise?——When?　1998

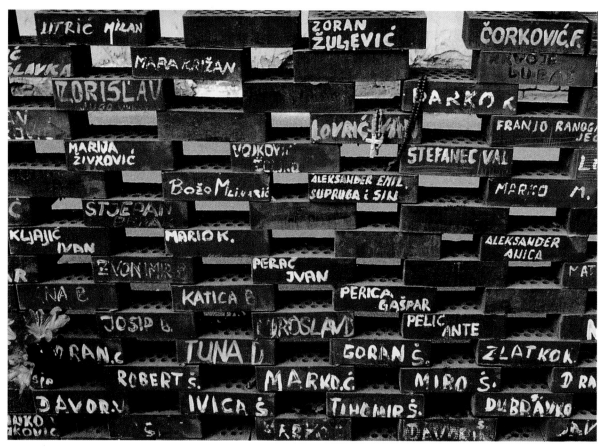

天堂？——什么时候？　1998
Paradise?——When?　1998

天堂？——什么时候？ 1998
Paradise?——When？ 1998

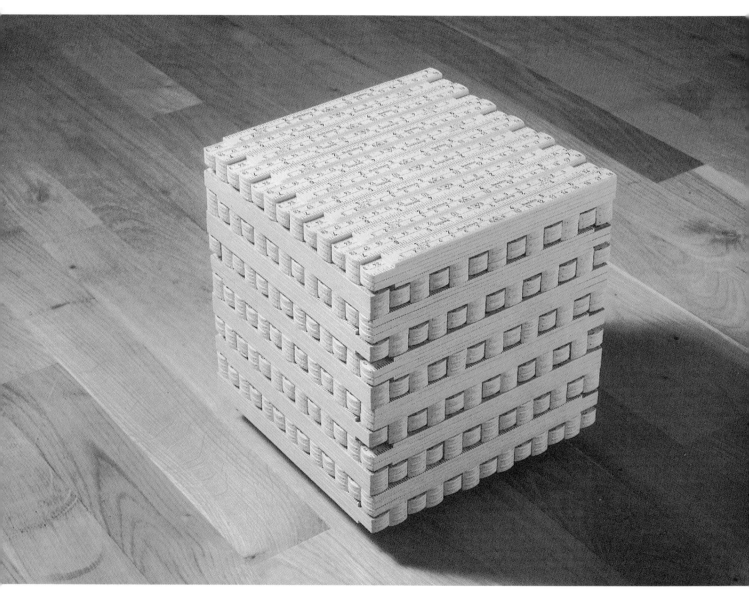

米的立方形　　1994
Cubic Metre　　1994

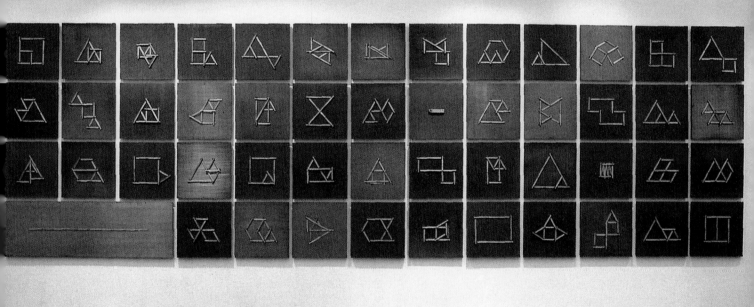

50 种米的形态　1992
Fifty Metres　1992

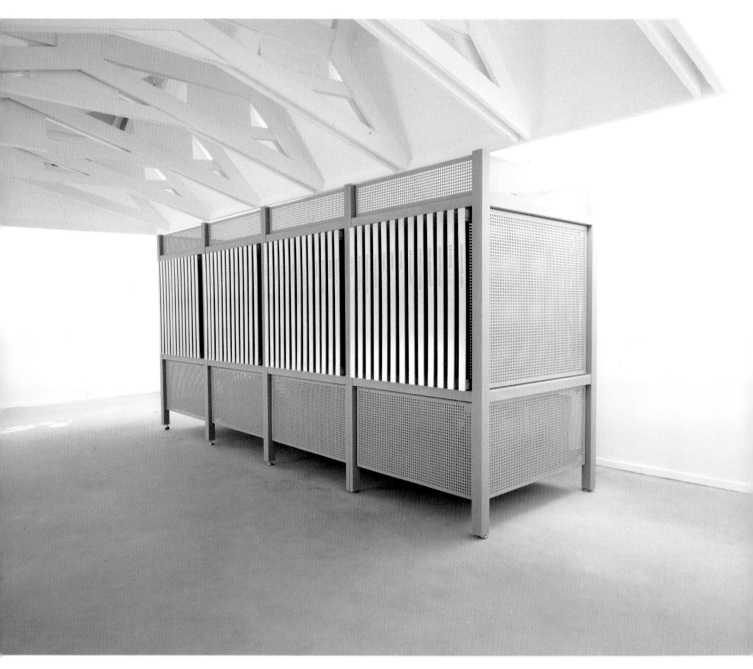

时间与水（装置）　2003

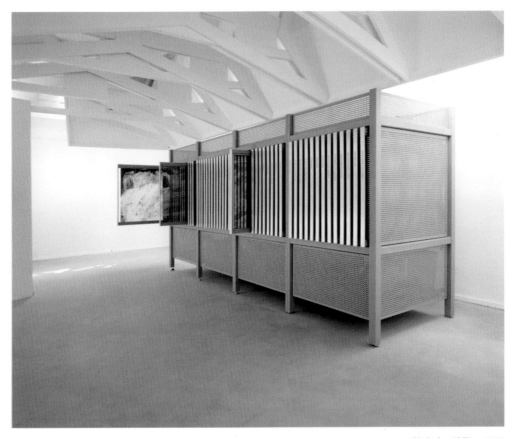

时间与水（装置）　2003

时间与水（装置）　2003

时间与水（装置）　2003

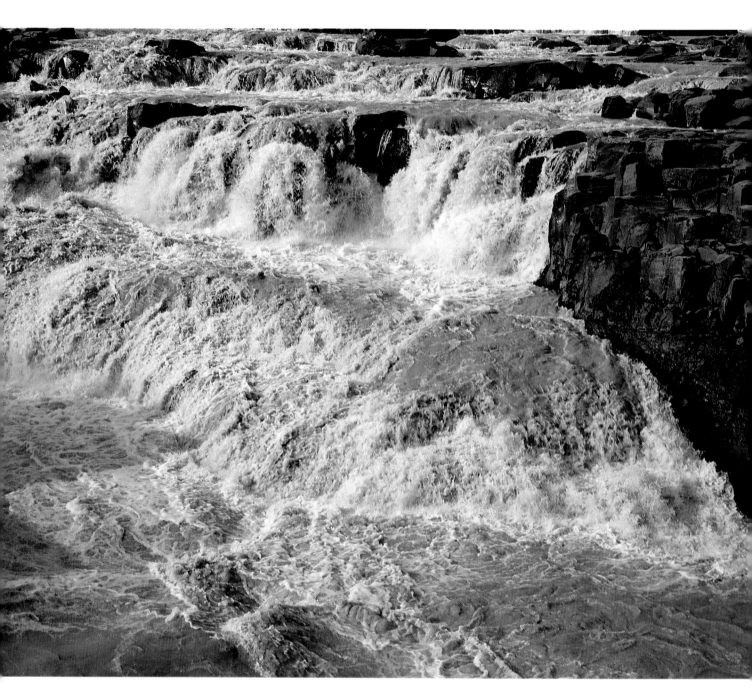

时间与水（装置）　2003

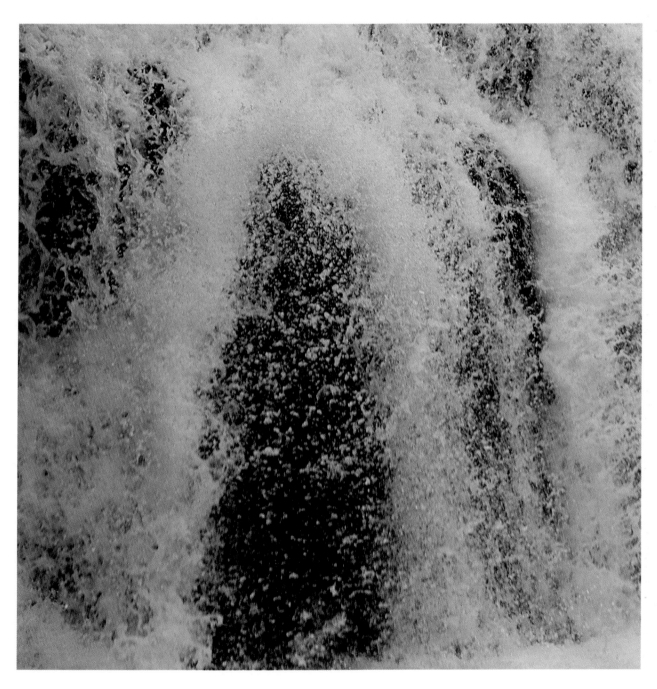

时间与水（装置）　2003

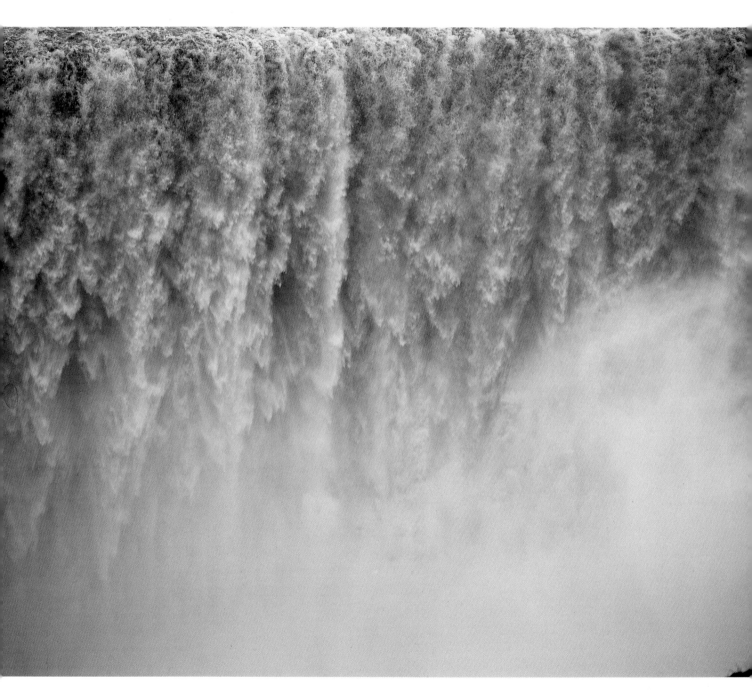

时间与水（装置）　2003

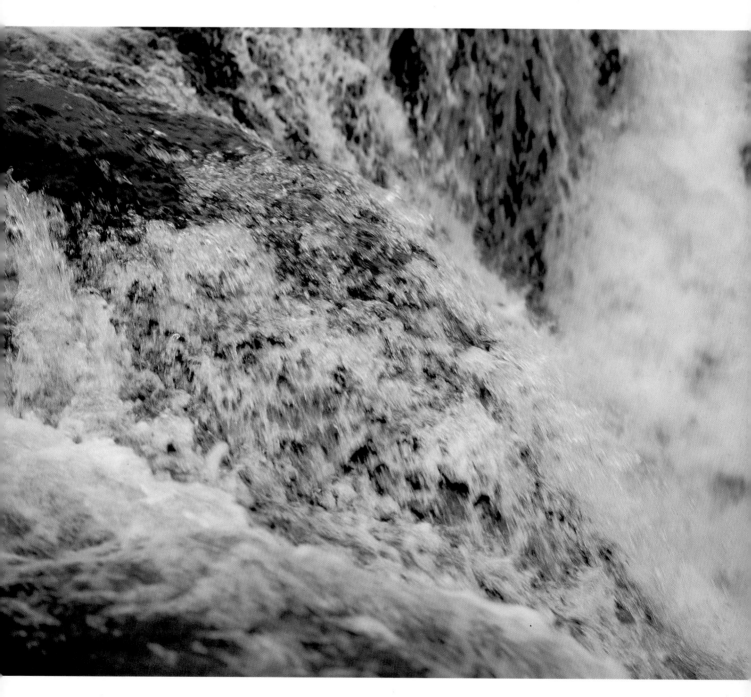

时间与水（装置）　2003

展厅外景